Sylvie Aubenas

PHAIDON
non mint copy

GUSTAVE
LE GRAY 55

Φ

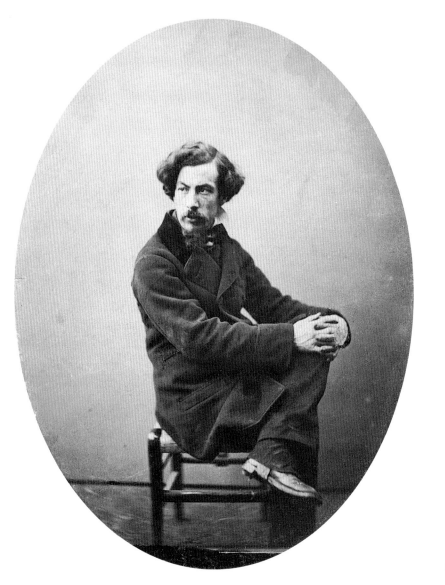

Gustave Le Gray, an artist whose work made him famous in his time, has been rediscovered in recent decades, at first by collectors and more recently by the public. He is now recognized as a major figure in nineteenth-century French photography and is even regarded as one of the founders of photographic art. The quantity and variety of his work, his contribution to the medium's technical and aesthetic development, his unshakeable faith in its future as an art form, and the influence he exerted through his many students all served to stimulate the dynamic spirit that made Paris the world capital of photography during the Second Empire (1852–70). Contemporary critics, artists and collectors hailed him as the perfect photographer, both an artist and a scientist, before a sudden reversal of fortune made him an exile and an object of scandal, and finally buried his name in oblivion.

Le Gray, the only child of elderly parents, was born on 30 August 1820 at Villiers-le-Bel, near Paris. His parents were wealthy haberdashers from the capital who dreamed of his becoming a lawyer. After his baccalauréat he worked as an office clerk with the local notary before convincing his parents that painting was his true vocation. He subsequently attended Paul Delaroche's classes at the École des Beaux-Arts, where he became friendly with Henri Le Secq and Charles Nègre, who were also to become photographers, and the painter Jean-Léon Gérôme. In the latter part of 1843, Delaroche had to close his studio and left Paris for Rome. Le Gray followed and, after a long journey, settled in the Corso district early in 1844. He remained there until spring 1847, leading the life of a young artist. His stay was, however, marked by his hasty marriage in spring 1844 to Palmira Leonardi, a young Italian girl of humble origins. During fifteen years of an apparently unhappy and ultimately doomed union, she was to bear him six

children, only one of whom survived him. It was also in Rome that he first became involved with photography.

On his return to Paris he continued to paint, without great success, and began to devote an increasing amount of time to his new interest. During the late 1840s the calotype (a paper negative) was causing a great sensation. This had been invented in England in 1841 by William Henry Fox Talbot, but initially aroused little interest in France, where the daguerreotype (on silver plated copper) was favoured for its precision of detail. Le Gray was still working with daguerreotypes in about 1847–8, and a few fine portraits using this process have been discovered recently (page 17). He soon turned to paper-based photography, however, and with his friends Le Secq, Nègre and Mestral, established himself as an outstanding practitioner of this technique.

In summer 1849 he began teaching the process, his first students being the scholar and aristocrat Léon de Laborde and the writer Maxime Du Camp, who was about to embark on a photographic tour of the Orient with Gustave Flaubert. A few months later, Le Gray opened a large studio-laboratory near Montmartre, at the Porte de Clichy. Here he lived with his family, worked and received his students. Several photographic landscapes (page 19), self-portraits (page 41) and portraits of students and friends (page 35) testify to his intense activity in and around this studio.

He extended his teaching work by producing the manual *Traité pratique de photographie sur papier et sur verre*, which was published in 1850 and ran to four enlarged editions under various titles, besides those published in England and America. He stressed the importance for artistic ends of an exacting

technique, a hallmark of his work throughout his life. He was also the first to explore the use of collodion-coated glass negatives, an idea that was perfected the following year by the Englishman Frederick Scott Archer. It would prove highly significant for the history of photography over the next three decades.

The year 1851 marked a turning point in photography, with the founding of the Société Héliographique (later the Société Française de Photographie) and the photographic journal *La Lumière*, with Le Gray playing an important role in both initiatives. Shortly afterwards he and four other photographers, Édouard Baldus, Hippolyte Bayard, Le Secq and Mestral, received a unique assignment. Their task was to travel throughout France to photograph all the major buildings that the Commission for Historical Monuments was planning to restore. Le Gray spent the summer travelling across the south-west with Mestral, returning to Paris with over six hundred negatives. These were produced using the 'dry waxed paper' technique that he himself had just invented. These negatives were more detailed and resistant than those created using wet processes, and unprecedented sizes were obtained (up to 30 x 40 cm; $11^3/_4$ x $15^3/_4$ in.). Moreover, he could prepare them in advance, enabling him to take up to thirty pictures in one day, an extraordinary quantity at that time. He was therefore able to go far beyond the original scope of the project, increasing the number of subjects and varying the lighting and the framing of the images.

When Le Gray returned, his prints excited great enthusiasm, both for their beauty and for their technical mastery. During this period, he also explored methods of printing and presented the Académie des Sciences with a new technique that enabled a whole range of tones to be achieved. The quality and variety of tones exhibited in the prints for the Mission Héliographique (such as

the deep blue used for the views of Moissac and Le Puy) clearly reflect this research. In this way, Le Gray used a documentary assignment to develop the technical and aesthetic aspects of his work.

He became increasingly busy. For three consecutive years (1851–3), he photographed the Paris Salon at the request of its organizer, Philippe de Chennevières. His images reveal the unexpected poetic potential of these official exhibitions, as statues appear to come to life, silently conversing in the half-light away from the public gaze. In 1852 he photographed the prince-president, who was already planning to become Napoleon III. Showing a somewhat rigid figure with a hazy, impenetrable gaze, this portrait was the first official photograph of a head of state.

Until 1855 the number of his students steadily increased. Mostly artists or gentlemen of leisure, many of them left their mark on the history of photography, including Adrien Tournachon (Nadar's brother), Olympe Aguado, Auguste Salzmann, Léon Méhédin, Eugène Le Dien and John B. Greene. With Greene and other artists, probably including Barbizon School painters, he explored the forest of Fontainebleau, initially using paper negatives to produce landscapes (page 45). In these general views, Le Gray organized the arrangement of mass and lines, juxtaposing rocks and vegetation, showing different views of the road to Chailly and depicting light penetrating the undergrowth. Chiaroscuro effects and backlighting merge perfectly with the grain of the calotype. A few years later, he was to treat light in quite a different way using a glass negative to produce portrait-like images of trees, in which a trunk's volume, the texture of a piece of bark or a shimmering mass of foliage, boldly framed, stand out against a luminously misty background (page 59). He also

reworked some earlier images, using the montage technique known as 'ciels rapportés' (a technique he developed mainly in relation to his seascapes), which combined a landscape produced from a paper negative with a cloudy sky taken using a glass negative. Further refined by the colours of the prints, these re-creations of reality express a more overtly pictorial vision of nature.

In 1855 Paris hosted the Exposition Universelle, where photography was superbly represented by Le Gray and Adrien Tournachon, among others. The new medium was already highly popular, with an ever-increasing number of commercial studios opening. With money from a business partner, the marquis de Briges, Le Gray rented a studio at 35 boulevard des Capucines. In spring 1856 his luxurious salons opened their doors to a fashionable clientele, and the following four years marked the height of his career. He photographed almost exclusively using collodion glass negatives, printing on albumen coated paper. He also extended the range and richness of tones produced through this method, notably with the use of gold chloride, a process he publicized in 1858.

From then on he made his living principally from portraits – actresses, writers, artists and famous public figures all visited his studio. The pleasing formula he developed featured a soft, misty background forming an oval-shaped halo. This style enjoyed huge success in its day. Designed to be set in an oval frame, these images presented an idealized image of the model, at the same time facilitating the retouching and tinting process. Although the plain borders and chiaroscuro effects associated with Nadar are more to present-day taste, it should be recalled that Nadar himself often used the oval shape which his friend and rival had popularized. Conversely, it has only recently been realized that, from an early date, Le Gray too created powerful portraits using effects

of contrast. These herald Nadar's style and are sometimes so similar that two at least were earlier thought to be Nadar's own work (portraits of the sculptor Auguste Clésinger and the philosopher Victor Cousin, pages 51 and 75).

Apart from portrait photography, Le Gray continued to photograph other subjects, achieving success in each new genre he attempted. Some female nudes have recently been discovered, three of which are particularly striking. These images, which use the same model, are gloriously sensual. Most notably, Le Gray was once more working in the service of Napoleon III, a role that crowned his success in the public eye. From then on the labels on his prints bear the title 'photographer to the Emperor'.

His first photographs in this capacity were studies of the Empress Eugénie and the new-born prince taken in 1856 (page 61). These were to be used for a large painting of the baptism by Thomas Couture, although this never materialized. The following year, Le Gray was asked to photograph the inauguration of a vast military training camp at Châlons-sur-Marne. These images were to be mounted in large albums, which the emperor would then present to his military staff. Le Gray worked there from August to October, producing images that display a remarkable variety of tone and composition (pages 87–93). The lively, picturesque (yet painstakingly arranged) scenes depict the soldiers' daily life, formal ceremonies, cavalrymen riding in the autumn mists, and military manoeuvres that threw up dust on the horizon of deserted landscapes. They show the photographer at the height of his creative powers.

During the same period, but on his own account, Le Gray produced the series of seascapes on which his reputation has always been based. The first of

these, *Brig* (page 65), was exhibited in London in late 1856. It created a sensation then, and still excites admiration. For three years Le Gray travelled to Normandy, Brittany and the Mediterranean, taking dozens of views of the coast. These were subsequently widely exhibited, particularly in England. Their reputation spread throughout Europe, even reaching the United States. Artists, critics, wealthy enthusiasts and princes snapped up the prints in their hundreds.

At a period when relatively long exposure times were still required, capturing the waves in movement was a considerable feat, particularly with negatives of such large format. In his seascapes Le Gray perfected the technique which he was also to use for some views of Fontainebleau, combining two negatives for sky and sea, as in *The Great Wave* (page 79). Different light levels entailed differences in the exposure time, so it was not generally possible to capture a view of the sky at the same time as the landscape. This obstacle was overcome by printing from two separate negatives, experimenting with clouds which appeared soft or dramatic in turn. Le Gray seems deliberately to have sought out increasingly difficult challenges, in order to emphasize his total mastery. He plays with the raging sea, direct sunlight and dazzling reflections, nonetheless retaining all his work's lyricism and creative inspiration.

During what was to be his last year in Paris, he produced a series of majestic views of the city. These include isolated monuments such as the Pantheon and the Tower of Saint-Jacques, which stand out sharply amid a golden light. He also produced general views of the Seine, contrasting the shimmering river with the static stone of the city (pages 99 and 101). This is the only series for which the glass negatives have so far been discovered. They provide a clearer

idea of the technical operations involved: the extremely large format (40 x 50 cm; $15^{3}/_{4}$ x $19^{3}/_{4}$ in.) requires very thick plates (almost 1 cm; $^{3}/_{8}$ in.), each of which weighs close to 2 kg. They also show that reframing was minimal, as the images were perfectly composed the moment they were shot.

Despite his artistic success, Le Gray had serious shortcomings as a business-man. He finally ran into difficulties when the de Briges family, tired of waiting to receive the much-publicized profits, withdrew their financial support. The firm of Le Gray and Company was dissolved in February 1860, leaving the way open for his students and rivals. Nadar himself was soon to move his studio into the building his friend had just vacated.

Then came an unexpected opportunity for Le Gray to make a fresh start, and maybe also to escape from his problematical family life. The novelist Alexandre Dumas had just sold the rights to his entire works and was preparing to leave on a cruise around the eastern Mediterranean, which had been his lifelong ambition. He gathered a crew of young people: his mistress Émilie Cordier; Paul Parfait, his secretary's son; Édouard Lockroy, a painter and future minister; the doctor Natalis Albanel, and Le Gray. The photographer was commissioned to take hundreds of images to immortalize the great man's jour-ney and the mythical eastern landscape. He could not have guessed that, of all those present, he alone would never return to Europe.

The triumphant departure from Marseilles took place in May 1860. Yet the planned route was changed almost immediately. Dumas learned that Palermo had been taken by the revolutionary army of Giuseppe Garibaldi, whom he had met a few weeks earlier and whom he admired greatly. Accordingly, they set

sail for Sicily, where Dumas and his escort were splendidly received by the 'Hero of Two Worlds'. In this way, the official photographer to the emperor became a war reporter in the service of the revolution, producing views of the ruins of Palermo, strangely grave and silent in the sunshine, and portraits of Garibaldi and his entourage. These images were sent to the Parisian newspapers, together with drawings by Lockroy. More colourful than heroic, the Sicilian adventure lasted until early July. Then Dumas and his friends set sail once more, unsure of whether to continue the cruise or to ship guns for Garibaldi. In Malta an unexpected turn of events ended this hesitation, when Dumas abruptly separated from Le Gray, Lockroy and Albanel. The immediate reason for this appears to have been a quarrel concerning Émilie Cordier.

The three marooned men wrote to the editor of *Le Monde Illustré*, offering their services. He immediately took them on, sending them to Syria to follow the expeditionary corps that the emperor had recently dispatched to the aid of the Maronite Christians, who were being massacred by Druze Muslims. On 17 September, however, as he was about to leave for Damascus, Le Gray's leg was broken by a kicking horse. He underwent treatment for this in Beirut and during his convalescence established a studio beneath the Roman ruins in Baalbek, where he produced some monumental images.

He then left for Alexandria, probably early in 1861. He acquired numerous clients in the cosmopolitan port, which was full of merchants and voyagers. He produced landscapes, portraits of the comte de Chambord (the Bourbon pretender to the French throne) and the Prince of Wales (page 117), and even picturesque small-scale images of local inhabitants (page 113), overturning the stereotypical images of 'The Orient' with a few artless masterpieces

depicting young children and workers. He continued to send his pictures to French newspapers, and even wrote to Nadar in November 1862, telling of his dispirited state, his bitter feelings towards the de Briges and Dumas, and his hopes of coming home. Returning, however, would mean either settling his substantial debts or facing prison; this may partly explain his prolonged exile. Yet other reasons, both private and public, also played their part. For in gradually abandoning the idea of seeing France again, Le Gray was effectively deserting his wife and children. For Palmira these were years of rootless wandering and appeals for help; in 1865, after one final, entreating letter to Le Secq, we lose sight of her altogether. This scandal helped to ensure that the name of her dishonourable husband – one of the few professional photographers who had ultimately given the activity an honourable status – was readily forgotten. His friends, students and admirers seem to have erased him from their minds immediately; his departure may even have contributed to the way photography evolved in his time, moving away from art and towards industry.

For Le Gray, however, these concerns were as yet remote. In 1864 he left Alexandria for Cairo, moving from the westernized city to the real Orient, the land of artists' dreams. There he was appointed to teach drawing at the military academies, which earned him a reasonable living during his last twenty years. He also received several commissions from the khedive of Egypt, Ismaïl Pasha. For the first of these, in 1866, he produced some remarkable images of camels loaded with pieces of artillery (page 119), the very latest in Egyptian military equipment. He also taught drawing to Ismaïl's six sons, and in early 1867 accompanied them on a journey along the Nile, making sketches and taking photographs himself. Motivated by being in the employ of his powerful protector, Le Gray returned with a wealth of magnificent images comparable to his finest

Parisian works. Once more alternating between glass and paper negatives according to the desired effect, he produced a succession of views of monuments (pages 123 and 125), group portraits and landscapes. Besides these, following a tradition already well established in Europe, he photographed industrial sites such as the sugar factory at Armant, of which the khedive was especially proud. A collection of these views, together with their associated drawings, was sent to the Paris Exposition Universelle in April 1867, yet the French photographic press made no mention of them.

Although he had once more taken up painting, Le Gray continued to produce photographic portraits and landscapes – mostly now lost – which he sold to rich Egyptian families and French expatriates in Cairo. He still encountered a few acquaintances who had come on their travels, such as his old friend the painter Gérôme and Philippe de Chennevières. Unlike most Europeans, however, he lived in ordinary districts in the city's Arab quarter.

He ended his days there in the company of a nineteen-year-old Greek girl, Anaïs Candounia. He referred to her as his wife but was unable to marry her not knowing whether Palmira was still alive. When he died in Cairo in the heat of July 1884, almost all he had left were cases of photographs, pictures and drawings, in addition to his artists' materials and his photographic and chemical equipment. The only surviving child of his first marriage was his son Alfred, who had remained in Paris; he sold everything and inherited a small sum of money. This was the second time, after his departure from the boulevard des Capucines, that Le Gray's collected work was dispersed. Prints dating from his Oriental period, covering nearly twenty-five years, took a long time to resurface and remain very rare today.

Gustave Le Gray's death went completely unnoticed in France. His name was not mentioned again until Nadar began to write his memoirs (*Quand j'étais photographe*) in 1892. And it was not until the late twentieth century, when the early history of photography became the subject of closer study, that the importance of the man and the distinction of his work once again became evident.

In Le Gray's work there is variety of subject matter, from portrait to architecture, from landscape to reportage, from Paris to Cairo. There is also variety of technique, which he ceaselessly perfected, constantly seeking the most suitable means to his ends and extending his ambitions. And yet there was unity and constancy, both in certain principles he held and in his steadfast refusal to compromise the artistic status of photography by giving in to the forces pulling the medium towards hard reality and money. It was Le Gray's credo that 'photography, instead of falling to the domains of industry and commerce, must enter the sphere of art' (1852). He used methods similar to those of painters and engravers: far from mechanically producing several images, he planned each one separately and spent a considerable time working on it, from taking the picture to modulating the tones and ambience of the final prints.

Certain recurring formal features characterize Le Gray's photographs. The image is framed following rigorous geometrical principles; the general composition is sometimes bold but always calculated. His experiments and radical approach to the photography of buildings culminated in his images for the 1851 Mission Héliographique, as a response to the lines and volumes of Romanesque architecture (page 22). Until then, his work reflected a certain taste for complexity, at times bordering on affectation; this was particularly evident in some of his portraits. Equally, although his first landscapes have a forceful quality, the

lure of the picturesque is still apparent (as in his *View of Montmartre*, page 19). However, the six hundred photographs taken in 1851 herald a phase of development which was to continue over the following years; his vision became broader and more refined, as demonstrated by the masterpieces he produced at the military camp in Châlons-sur-Marne, his seascapes and the views of Paris.

Certain basic principles of composition can be detected. The feeling of space is created by an empty expanse in the foreground, emphasized in depth by long horizontal lines (a beach, a line of soldiers, a jetty, a barricade, the horizon), anchored by dynamic vertical lines (a tree, a pillar, a lighthouse) and brought together by a unifying feature, which might be the sunlight or a receding diagonal line, a forest path or a Parisian embankment. Even the emptiest spaces are structured by subtle, harmonious interactions. Despite the variety of subject matter, proportions or mood, a recurring feature in these images is the contrast of two opposing elements – stability and movement; a mass of shadow and a flash of light; a frontal image and a receding vista; a compact form and an isolated motif – creating a tension that brings the whole image to life. In the morning mists of the Champagne area, the long rectangle of a breastwork, enlivened by the soldiers' bearskin hats, is countered by the figure of a horseman (*Manoeuvres on 3 October 1857*, page 89). In the same way, the jetty and sail in *The Broken Wave* (page 81) offset one another. Taken to extremes, these principles culminate in the minimalist vision of a cloud of dust on the horizon, or a boat pinpointed in the centre of the image between sky and sea, in which the isolated motif, reduced to virtually nothing, gives form to the limitless space. It is perhaps at these moments that Le Gray comes closest to departing intentionally from the world of academic painting and engraving, to pursue a purely photographic aesthetic.

Portrait of Pol Le Cœur (1835–1908), Paris, 1848. Pol Le Cœur was the son of the architect Charles Clément Le Cœur. He is shown wearing the uniform of a schoolboy in the Second Republic (established in 1848). This smiling, natural portrait appears unconstrained by exposure time or decor. It was probably taken for his dying mother, as his studies prevented him from being with her. The photographer's obvious confidence suggests that the few daguerreotype portraits recovered to date form only a small part of his output between 1847 and 1849.

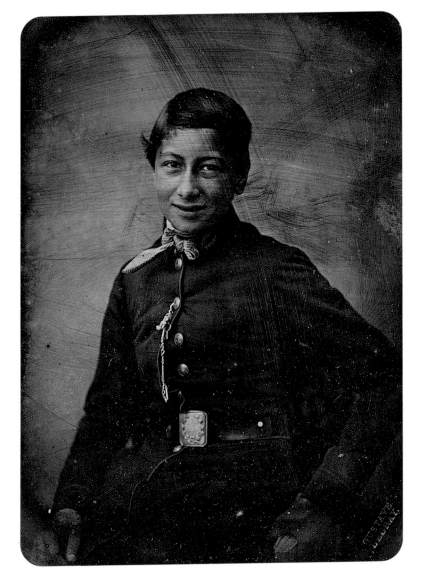

View of Montmartre, 1849–50. Le Gray could see the hill of Montmartre from his window. At that time it was still rural in appearance and crowned with windmills. There was no suggestion of the artists' haunt it was to become at the end of the century, and it was still an unusual choice of subject. Even so, it lent itself to the composition of a picturesque landscape, forming a succession of horizontal elements centred on contrasting dominant motifs, unified by the oval format. Although Le Gray took this photograph in 1849–50, the sky, which is from a different negative, was added in 1855–6. On a technical level, the combination of the two negatives, glass and paper, reflects Le Gray's unique skills at a time when images of the sky tended to be obtained by painting the negative.

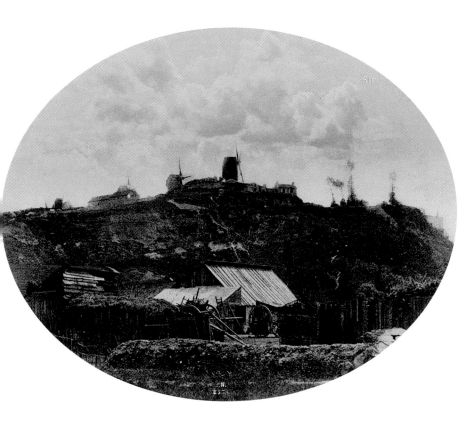

West Front of the Cathedral, Tours (negative), 1851. The delicate precision of detail obtained from the dry waxed paper process, which can reveal the finest moulding on a building, is spectacularly evident on this negative, for which no print is known. Here the cathedral takes on the appearance of a finely chiselled silver shrine. The camera on its tripod relates to a discreet self-portrait of the two friends, Le Gray and Mestral, who are sitting in the back of a cart. This serves as a symbolic testimony to their close artistic alliance while working on the series of photographs for the Commission for Historical Monuments in the summer of 1851.

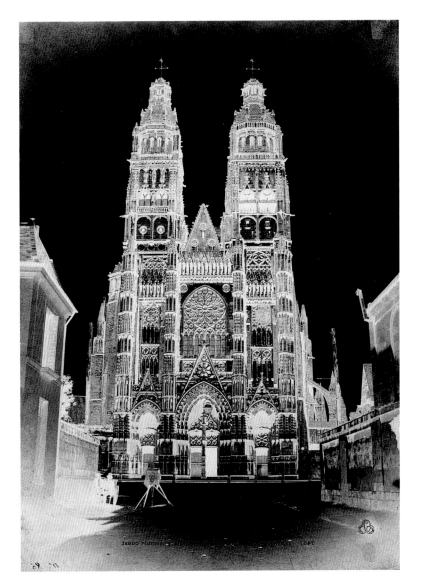

311

(previous page) **Church of Saint Vincent, Le Mas-d'Agenais, 1851.** The photographer's main aim here was to display the sculpted modillions beneath the Romanesque cornices, but the effect of the low-angle shot and the resulting composition totally overturn the conventions associated with photographing architecture, such as frontal views and a clear sense of form. This image displays a bold example of 'constructivist' geometry.

Cloister, Abbey Church of Saint Pierre, Moissac, 1851. Here the powerful chiaroscuro effects and the blue shade of the print create the illusion of a moonlit vision. The serene, balanced perfection of the gallery is discreetly enlivened by the intrusion of two vague forms glimpsed in the shadows, one of which is either Le Gray's hat or Mestral's. The abundance of vegetation seen beyond the small columns hides another signature item – in the exact geometric centre of the image stands a camera on its tripod, as a symbol of the artist's presence.

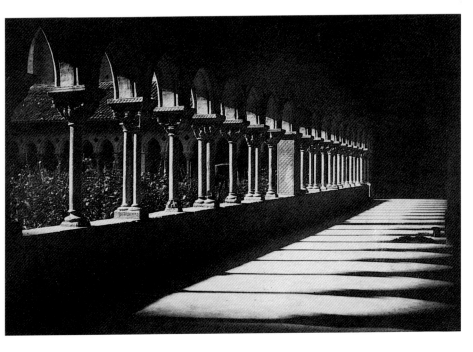

The Valentré Bridge, Cahors, 1851. The famous Valentré Bridge stands out against the water, where its image is reflected and extended, and the clear sky, which combine to highlight its bold architectural design. The photograph features both vertical and horizontal symmetry: the right side, with its shady vegetation, counterbalances the exposed and sunny left side. This view shows how Le Gray combined the official demands of his essentially documentary mission with his concept of photographic art as the creation of unique images.

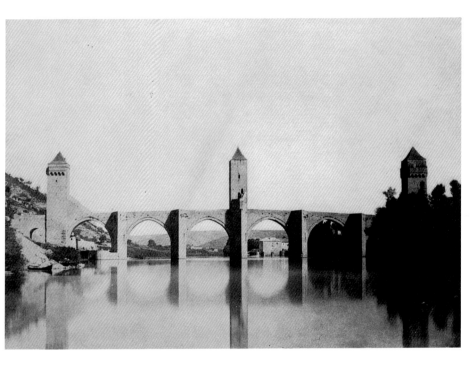

Porte Narbonnaise, Carcassonne, 1851. This composition in light and shade could almost serve as a metaphor for photography. Remarkable technical skill would have been required both to take the photograph and to print it. The material elements of the stones, paving and masonry remain perfectly visible in deep shadow next to an intensely bright sunny space. The view was rejected by the Salon de Peinture in 1852, together with two other photographs that Le Gray submitted, on the grounds that photographs were not works of art.

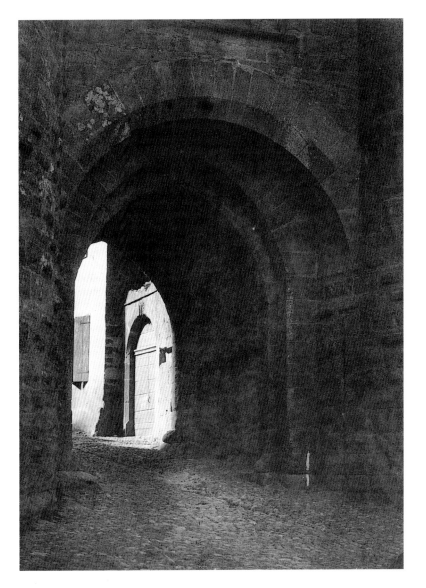

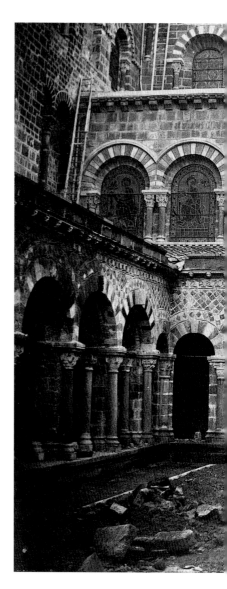

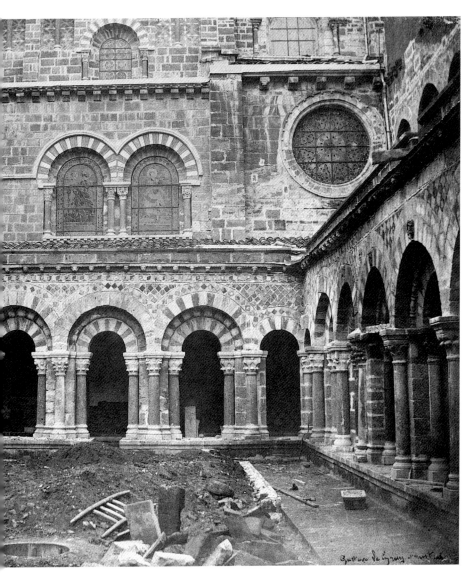

(previous page) Restoration of the Cloister, Cathedral of Notre Dame, Le Puy, 1851. Le Gray was in Le Puy while the restoration work planned by the architect Mallay was in progress. Far from ignoring this activity to focus on the architecture alone — as he did with another image from the same viewpoint, open to the sky — he integrates all the prosaic, untidy traces of the work into an enclosed space. They serve to counter the harmonious sequence of arches and the richness of the multi-shaded geometrically arranged stonework. The rare bluish tint of the print and the handwritten signature of Le Gray, giving both his own name and that of Mestral, make this one of the most remarkable photographs from the Mission Héliographique.

Hôtel de Cluny, Paris, 1851–2. The Hôtel de Cluny was the former Paris residence of the abbots of Cluny and is a magnificent example of late gothic style. It was acquired by the state, together with its collections of medieval art amassed by Alexandre du Sommerard, and became a museum shortly afterwards, in 1844. This photograph, which was probably commissioned, is more reminiscent of Walter Scott than of Viollet-le-Duc. In other words, it reflects a romantic vision of the Middle Ages rather than serving as documentation for architects. Le Gray dramatizes the central image by surrounding it closely with a dark shadow and bare, ghostly branches. It shares technical and aesthetic similarities with the series produced for the Mission Héliographique.

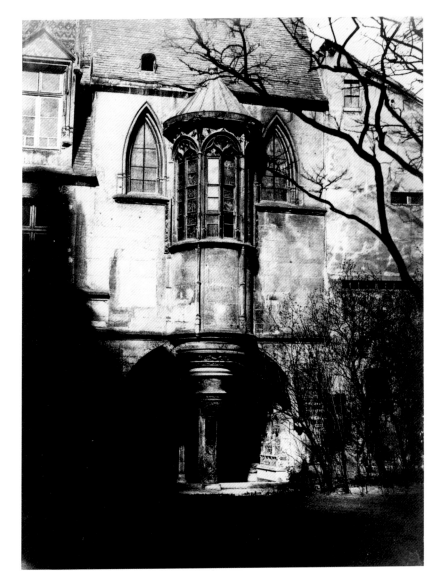

Portrait of Edmond Cottinet, Paris, 1851–2. This sparingly delineated calotype depicts the playwright Edmond Cottinet leaning dreamily against a wall. It is one of the recently discovered works which indicate that Le Gray, whose portraits were long thought to be of no account, was in reality one of Nadar's immediate precursors. Like Nadar himself, he selected his models from among his friends, artists or men of letters. This 'gallery' of portraits represents the work of about twelve years, ranging from the most personal to the most commercial of images. The collection is difficult to reconstruct, but displays a richness and variety that we are only now beginning to appreciate.

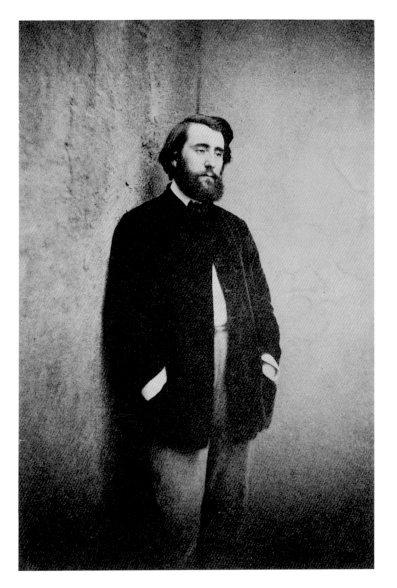

Garden Scene with Rake, 1851–3. Although reminiscent of several similar garden scenes captured by the early photographers Talbot, Bayard and Regnault, this image is an isolated example among Le Gray's works. It is further set apart by the use of a glass negative for an image where any other photographer would probably have preferred the soft chiaroscuro effect obtained from a paper negative. This choice enabled Le Gray to combine the poetic quality of a humble subject with his predilection for geometrical rigour and variety of form, texture and lighting. This is an awe-inspiring feat, given the image's extremely limited space and restricted range of shades.

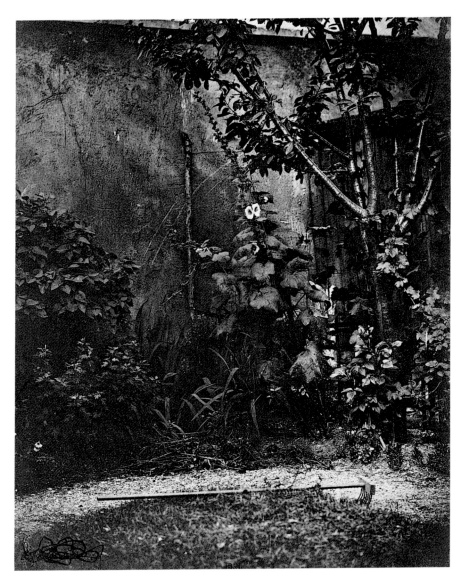

A Group of *Pifferari*, **Italian Street Musicians, Paris, 1851–3.** The Italian musicians who wandered the streets of Paris inspired several artists during the 1850s, including the photographers Charles Nègre and Louis-Camille d'Olivier, as well as the painter Jean-Léon Gérôme. Here Le Gray has presented them without the setting of a street or studio; they appear as an isolated picturesque motif. The precise detail obtained with the use of collodion is softened by a blurred effect on the child's face and by the intensity of the rich green-black shade.

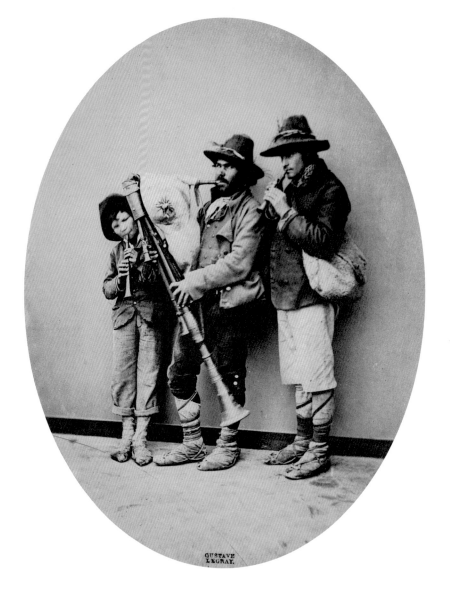

GUSTAVE
LEGRAY.

Self-Portrait Attributed to Le Gray, Outside His Studio, Barrière de Clichy, Paris, 1851–4. Here is the young teacher, in front of the same wall where several of his students were photographed. There is a touchingly personal quality to this image; in the soft evening light, the clenched fists, closed eyes and crumpled overall faithfully portray the man whom his friend Léon Maufras compared to 'one of those poor, fifteenth-century madmen who devoted themselves to alchemy and spent long years wasting away in laboratories'.

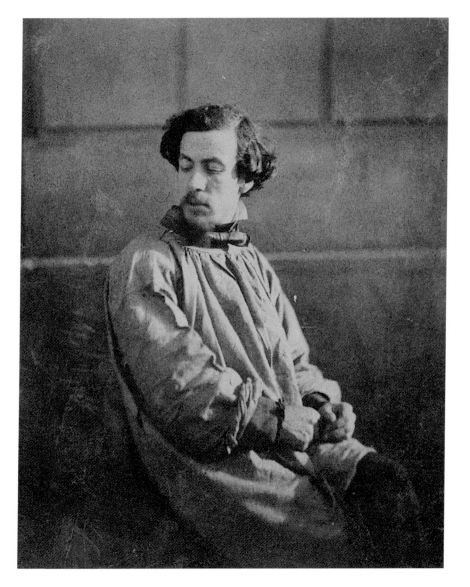

The Terre-Noire Factory, near Saint-Etienne, 1851–5. The Saint-Etienne coalfield is one of the oldest industrial sites in France. The coal and metallurgical industries had been operating in the area for generations, filling the landscape with smoke and transforming the natural environment into a scarred victim of human activity. Photographs of factories dating from this period are extremely rare. Le Gray was undoubtedly asked to take the picture by the factory owner, putting his signature to one of the first works of art dedicated to a theme that was to inspire so many photographers during the twentieth century, including Eugène Atget, Walker Evans and Bernd and Hilla Becher.

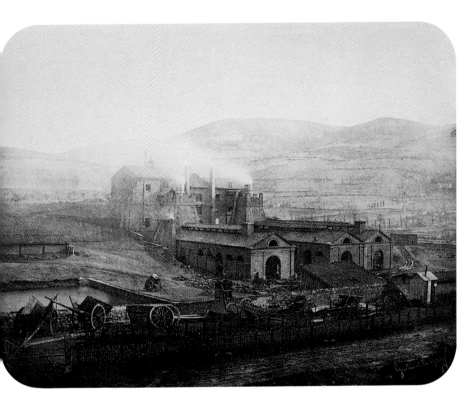

Road to Mont-Girard, Forest of Fontainebleau, 1852. This intense photograph displays a dynamic composition, juxtaposing the contrasting shapes and material of the track, the mossy rocks and foliage standing out against the sky. In the lower right-hand corner it is just possible to make out a slender stick which has been stuck into the ground and which can also be seen in other photographs. This may have served as a marker for Le Gray or a student who was accompanying him. This view forms part of a series taken at Fontainebleau in the early 1850s, for which paper negatives were used.

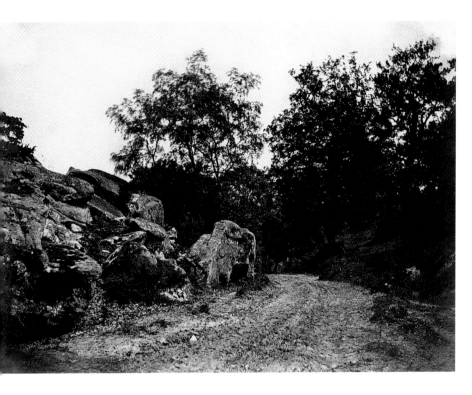

Portrait of Louis-Napoleon Bonaparte as Prince-President, Paris, 1852. 'All our Parisian subscribers have certainly seen the portrait of the President of the Republic on sale in the major print-dealers' shops, as a considerable number have been issued over quite some time. It is a fine, very forceful portrait and is most artistic in effect.' This is how the journalist Ernest Lacan, writing in *La Lumière* on 28 August 1852, described the first ever official photographic portrait, commissioned by Bonaparte, soon to become Napoleon III. The meditative sternness of the sitter and the armchair itself, reminiscent of a throne in the style of the First Empire, point to the impending re-establishment of the Bonaparte dynasty. Until his departure from Paris in 1860, Le Gray was to receive a number of commissions from the emperor and, together with Disdéri, Baldus and Marville, was one of his official photographers.

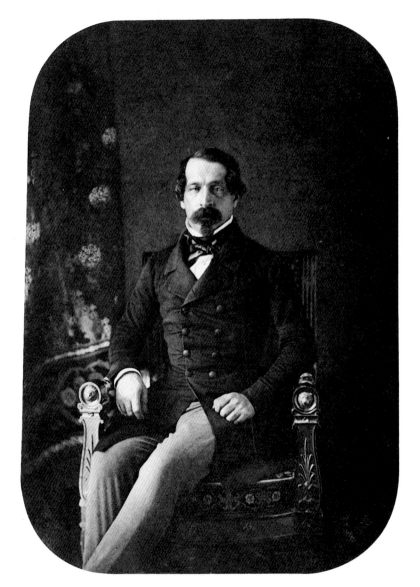

View of the Salon, Paris, 1853. For three successive years, the organizer of the annual Paris Salon, Philippe de Chennevières, asked Le Gray to take pictures of this major art exhibition. While other images he made of the Salon principally centred on the silent dialogue between the white statues in the half-light, this is more complex, emphasizing the interaction of strong receding lines and a whole range of lighting effects and reflections. The way the image is constructed leads the eye up towards the roof timbers, and the large sky-lights also lend the empty exhibition hall the less formal atmosphere of a large artist's studio.

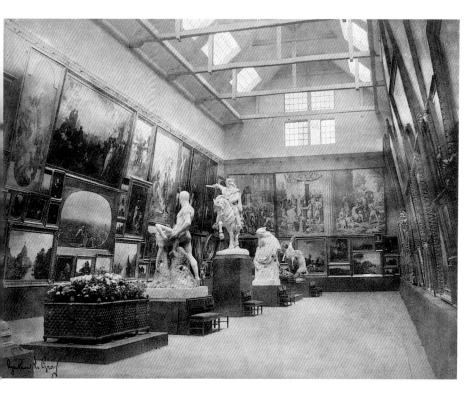

Portrait of the Sculptor Auguste Clésinger, Paris, 1855. Long thought by historians to be a masterpiece by Nadar, this portrait was presented by Le Gray at the Paris Exposition Universelle of 1855. The expertly achieved chiaroscuro effect against the neutral background, the forcefully framed image and the animated expression of the model, informally dressed and in a spontaneous pose (showing a strong, rough hand) all indicate that he could handle the genre with absolute mastery, even though – unlike Nadar – he did not specialize in it.

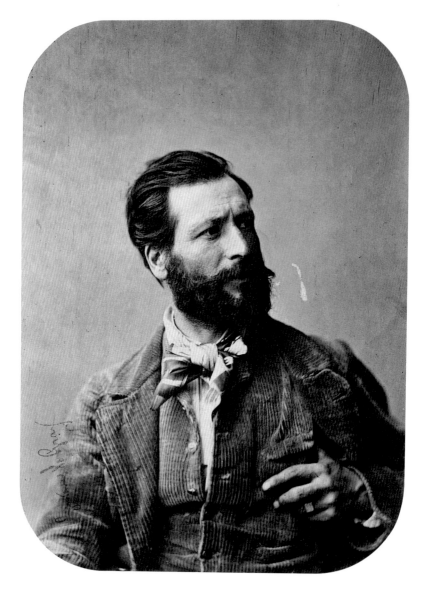

Study of a Tree Trunk, Forest of Fontainebleau, 1855–7. This monumental tree trunk standing in splendid isolation in front of a curtain of younger trees appears to form a 'living pillar' (as Baudelaire would have put it) supporting a vast dome of foliage. The extreme delicacy of the waxed paper negative has enabled the photographer to display the diffused light to advantage. Its reflections on the smooth bark stand out against the chiaroscuro of the forest and on the mossy rock which blocks the foreground, creating a base for the surge of vertical lines.

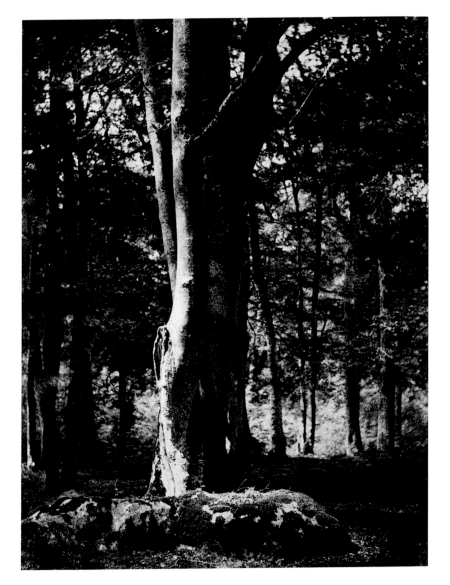

Study of a Tree, Forest of Fontainebleau, 1855–7. This oak tree is one of the studies of trees made by Le Gray in the forest of Fontainebleau using glass negatives, which make the images extremely sharp. From 1855 onwards Le Gray used both glass and paper negatives in turn, achieving mastery of both techniques. He improved on the way they were employed, choosing whichever was better adapted to presenting the subject matter as aesthetically as possible. Here, arranged around the strong diagonal form of the tree, the delicate foliage stands out against the white of the sky. In the same way, the white paving stones contrast with the dark ground, indicating that the picture was taken beside a track.

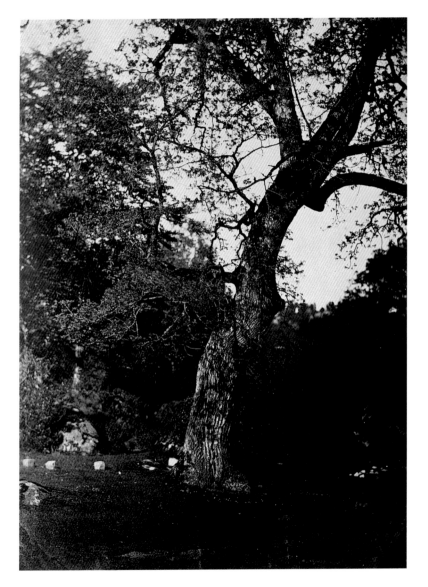

Study of Tree Trunks, Forest of Fontainebleau, 1855–7. This view was taken just beside the road to Chailly, its white line being visible in the background. The photograph frames the lower part of a clump of robust but slender trees. This results in a concise composition, closely surrounded in the foreground by shadows, which echo the principal motif. The whole is enriched by the study of various textures in a bright, low-angled light. The dynamic result reflects a sharp, intuitive awareness of photography's potential, at a time when the pictorial model still held sway.

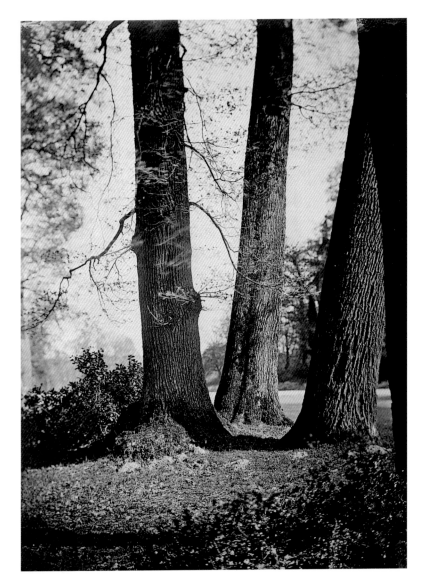

Beech, Forest of Fontainebleau, 1855–7. When he began photographing the forest of Fontainebleau using glass negatives, Le Gray favoured close-up views of isolated trees. The finely detailed result brings these subjects very much alive. At the time, they were collected by several painters, who kept these views among their papers, possibly to serve as inspiration. The *Beech* is particularly spectacular on account of its construction and luminosity. Against an out-of-focus background, a short trunk stands all but over-exposed – enveloped in a whirl of shimmering foliage, it appears to be dancing on its roots.

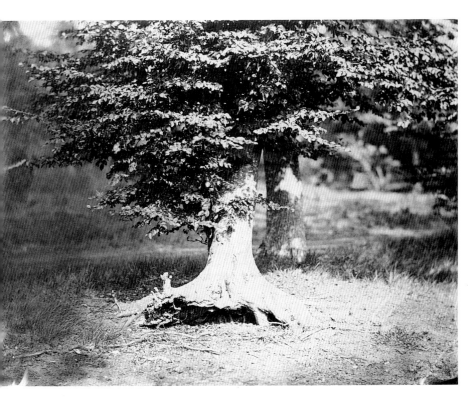

The Empress Eugénie at Prayer, Saint-Cloud, 1856. In 1853 Napoleon III had married Eugénie de Montijo, who came from a noble Spanish family. In 1856 they had a son, who was baptized in the cathedral of Notre Dame. A large commemorative painting was commissioned from Thomas Couture to mark the occasion. The artist asked Le Gray to photograph the empress in the position he had planned, to avoid lengthy posing sessions. As the picture was never completed, all that remain are the preparatory photographs. Here the figure of the empress, swathed in muslin, stands out against a velvety black background, creating an image of majestic simplicity.

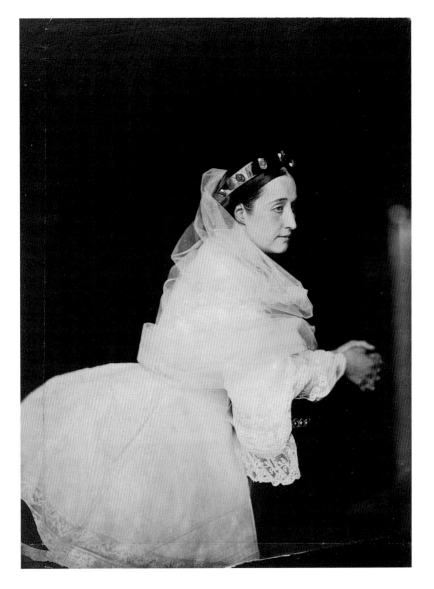

Reclining Nude, Paris, 1856. This nude, which has recently come to light, is the finest example of Le Gray's work in this genre. Suggesting a Baudelairean fantasy, the sensuality of the image combines the abandon of feigned sleep and mermaid-like hair with exactitude both in the pose and composition. The background is neutral, the frontal view of the couch provides a strong horizontal element, the draping lends an air of quiet fullness and the incandescent chiaroscuro effect of the photograph is reminiscent of a Rembrandt painting.

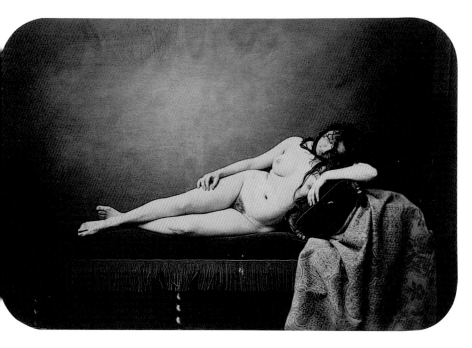

Brig, Normandy, 1856. This photograph contributed more than any other to establishing Le Gray's reputation for seascapes, particularly in England. When it was first exhibited in London in late 1856, it was hailed as 'the finest photograph yet produced', and was said to have immediately sold 800 copies at 16 shillings apiece. Prince Albert bought one, which he loaned to the Manchester Art Treasures Exhibition in April 1857. The combination of sea and sky from a single negative was an impressive technical feat. And it is because of the dramatic lighting obtained by Le Gray that this image is traditionally, but mistakenly, known as *Brig in the Moonlight*.

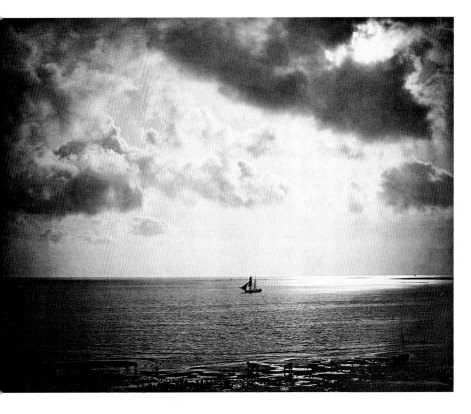

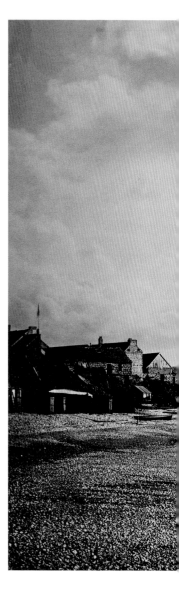

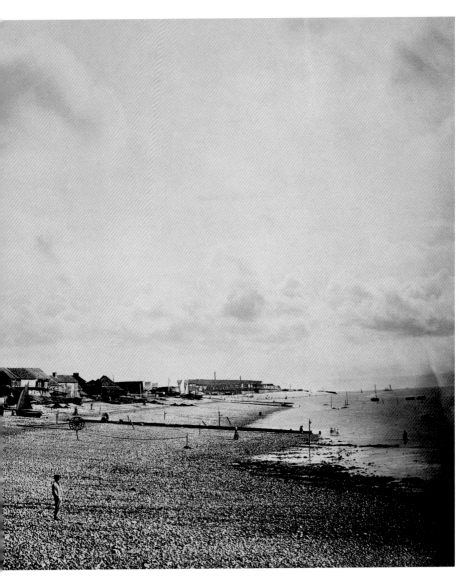

(previous page) The Pebbles (the beach at Sainte-Adresse), c.1856. The figure in the foreground is an example of how an unobtrusive detail is used as a landmark in the depths of the perspective and as a point of balance in wide vistas. This is a painterly feature typical of many of Le Gray's compositions. This print has clouds, but there is another version of the same view with a clear sky. The beach at Sainte-Adresse, near Le Havre, was to become a favourite haunt of the Impressionist painters. When Le Gray took this photograph, it was beginning to become popular as a resort but had not yet begun to attract artists.

Steamboat, Normandy, 1856–7. Here the composition and print have been planned in order to exploit the marked contrasts within the image. The cold shades, the neutral sky and sea presented in a dark halo, and the silhouette of the sailing boat stand out clearly against this background, together complementing a principal theme worthy of Turner – the sooty wreaths of smoke emitted by the tugboat.

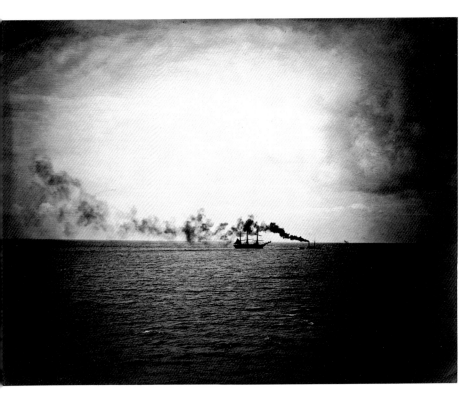

Seascape, Study of Clouds, 1856–7. This is a rare type of seascape, as the sky occupies almost the whole surface of the image. The wind and sun give the low clouds volume and movement, and this alone creates and shapes a genuine landscape.

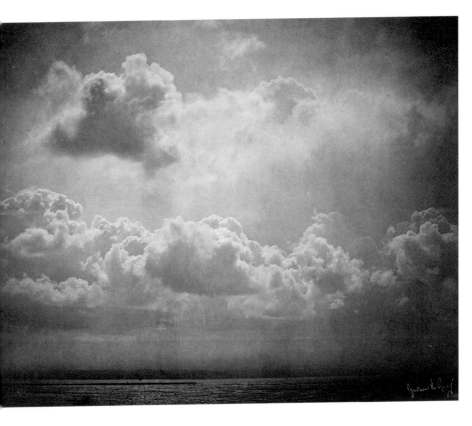

Self-Portrait, Paris, 1856–9. This self-portrait dates from the period when Le Gray was working in the large portrait studio he had opened on the boulevard des Capucines. The technique and style, with its blurred, oval-shaped background, are characteristic of his work at this time, catering for the demands of a wealthy and somewhat conventional clientele. Following the informal self-portraits of a young, bohemian artist (page 41), we now have 'Gustave Le Gray, photographer to the Emperor'.

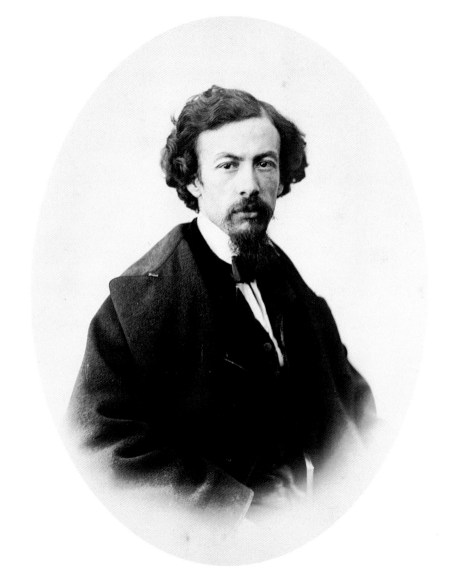

Portrait of Victor Cousin, Paris, 1856–9. This portrait, with its intense chiaroscuro effects, was for some time attributed to Nadar. In 1868 it was used by Henri Lehmann for his posthumous portrait of the philosopher, intended for the Sorbonne. It testifies to the qualities of Le Gray as a studio portrait artist which are underrated nowadays, just as his otherwise frequent practice of eliminating the background around the subject is today seen as an outmoded commercial convention.

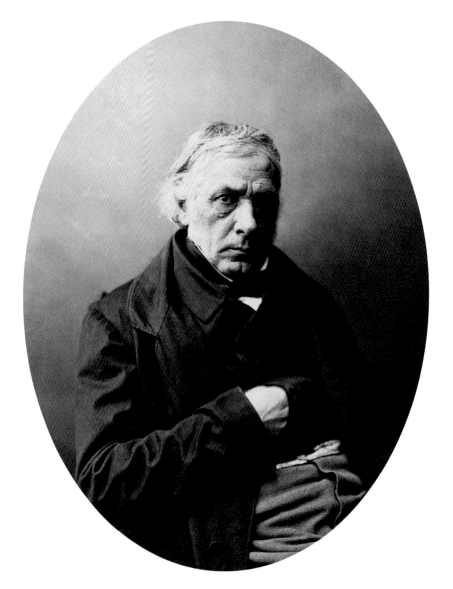

Panoramic View of the Port, Sète, 1857. A variant of this view exists, in addition to the prints that were re-cut by Le Gray to emphasize the horizontal aspects. This composition shows a tight, compact group of port buildings and crowded masts on a long rectilinear base, standing between sky and sea, and distanced by the presence of the buoy in the foreground. This is one example of Le Gray's use of the halo produced by the camera lens to frame and emphasize his main element. By introducing this purely photographic effect, he is reworking a classic subject.

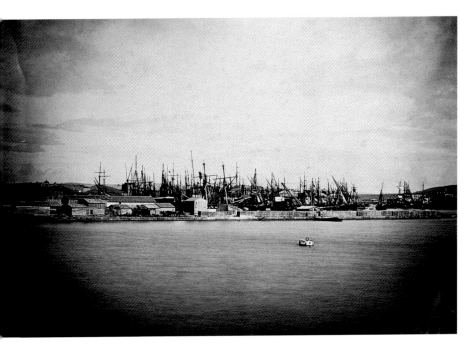

The Great Wave, Sète, 1857. Although this seascape is a romantic vision, the scene is superbly well constructed. Of all the works which have led to the public's rediscovery of Gustave Le Gray, this has had the most impact. The sombre clouds offset the rocks, while the black bar of the jetty and the dark, finely printed mass of waves in the background project the splash of white horizontal lines towards the spectator. Two photographs were needed to produce this image, the negatives being joined at the horizon.

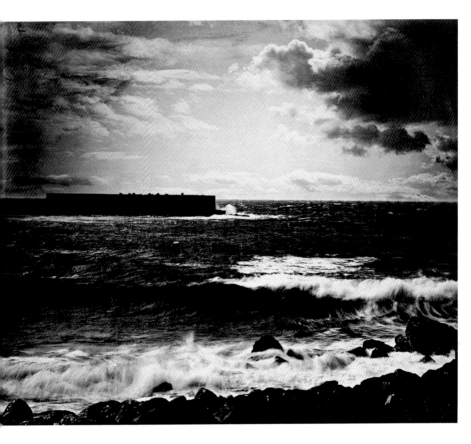

The Broken Wave, Sète, 1857. Like *The Great Wave*, this view forms part of the series taken in Sète in the spring of 1857. The setting is the same, yet here the originality lies in the vertical format, an unexpected choice for a seascape. Two main elements interact in the image: the rolling foam crashing against the dark rocks in the foreground echoes the silhouette of the sailing boat, which moves in line with the black jetty, a white wave-crest and the horizon. Its technical bravura made the fleeting beauty of this composition even more impressive in Le Gray's time.

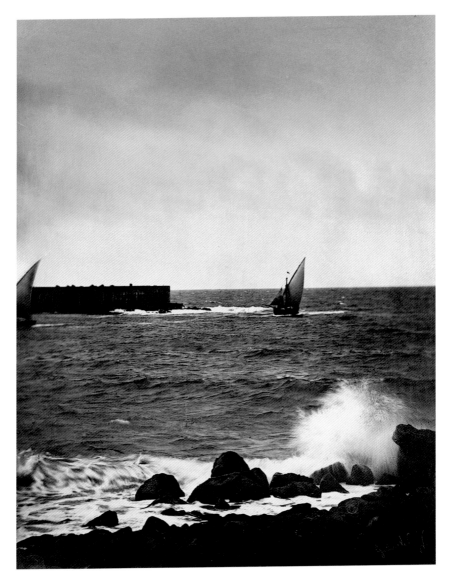

Stormy Sky, Mediterranean Sea, Sète, 1857. The atmosphere in Le Gray's seascapes is either serene or menacing. These effects are achieved by the additional element of clouds and the intensity of the prints. By increasing that intensity to produce a very dark image such as this one, using the gold chloride he favoured at the time, he has produced a highly dramatic picture of a sea which was actually calm.

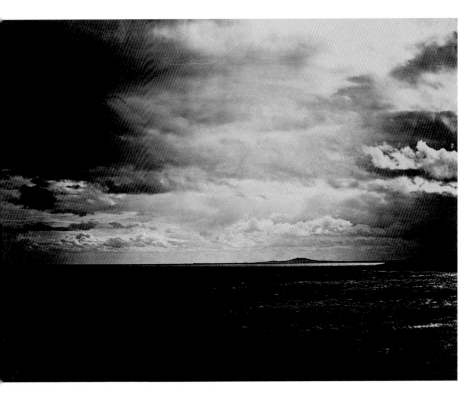

Mediterranean Sea, Sète, 1857. Mount Agde, seen on the horizon, serves as a key element in several views of Sète taken in the spring of 1857. Here there are no waves or sails — the merging reflections of a golden sea beneath a vibrant sky constitute the sole theme of this 'enchanted tableau', as Le Gray's contemporaries called his works.

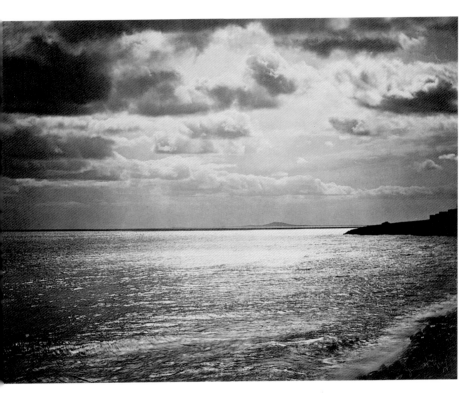

Napoleon III on Horseback, Châlons-sur-Marne, 1857. This recently discovered portrait does not feature in any of the official albums of the military camp at Châlons-sur-Marne. It was probably excluded on account of its evident flaws, chief among these being its over-exposure, which has made the shapes appear scorched and worn away. Today it deserves to be recognized as a truly original piece in comparison with the solemnly banal images normally characteristic of portraits of monarchs.

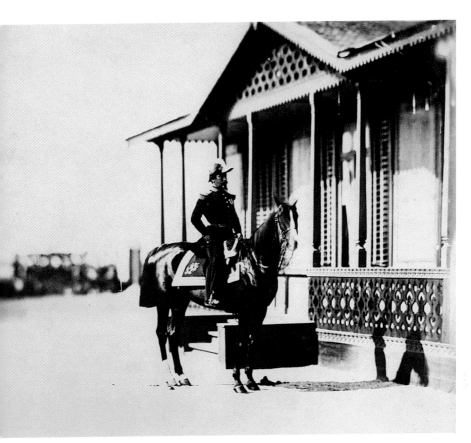

Manoeuvres on 3 October 1857, Châlons-sur-Marne. The military manoeuvres performed in the emperor's honour for the inauguration of the new military camp at Châlons-sur-Marne were widely documented in Le Gray's photographs, which officially marked the occasion. The power and austerity of the composition recall the seascapes produced shortly before this event. The central motif stands out, creating a shadow-play effect, against a background of morning mist suspended between sky and earth. The figure seen in profile on horseback on the right is probably Napoleon III himself.

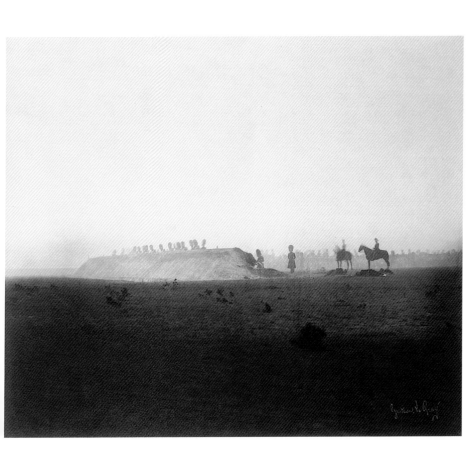

Zouave Storyteller, Châlons-sur-Marne, 1857. Daily life in the camp and the various army corps represented there form the theme of several photographs. This carefully composed scene shows to advantage the bronzed faces of the Zouaves and their picturesque costumes. The visual power of the contrasting elements and figures, accentuated by the dynamic quality of the prints, ensure that Le Gray's work is no mere copy of the Napoleonic military imagery so fashionable at that time.

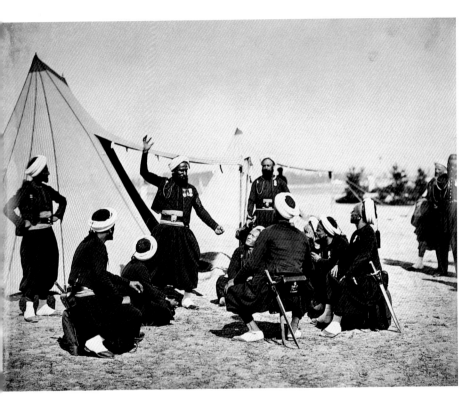

Scene before a Watermill, Châlons-sur-Marne, 1857. In addition to his work for the emperor, Le Gray took at least two photographs of the watermill at Petit-Mourmelon, situated near the camp. There is no military element here: the mill and its pond serve as a theatre, staging a lively scene peopled with figures that have been very carefully posed by the photographer. The image recalls the type of country amusements popular with bourgeois city-dwellers, perhaps visitors to the camp, as this view appears in certain official albums. This scene is difficult to categorize, being neither a landscape nor genre work. It is an unusual combination of a rustic setting with an elaborate composition and a distribution of figures verging on artificiality.

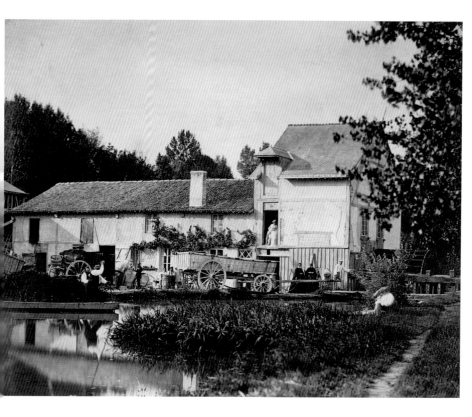

Clouds, c.1857. This spectacular sky, taken in an unidentified location, differs from other known works by Le Gray, as his studies of clouds normally feature in seascapes rather than landscapes. Certain details on the horizon may recall the site of the military camp at Châlons-sur-Marne, which he photographed around the same time as the seascapes. It is possible that Le Gray had initially framed the sky so as to reuse it in combination with another negative.

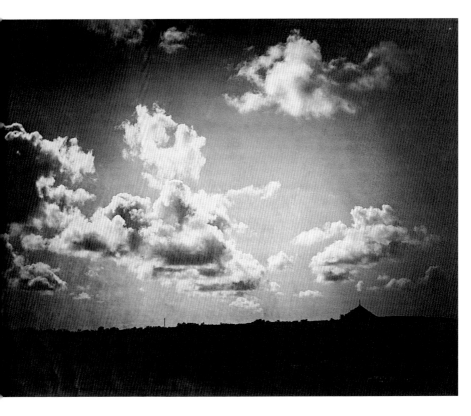

French Fleet, Cherbourg, 1858. The French and English fleets met at Cherbourg in August 1858, as did their respective sovereigns. Photographs taken to mark this occasion may also be found in Queen Victoria's private collection. The official French photographer was Édouard Baldus, but Le Gray made a series of prints on his own initiative. These demonstrate his expertise in a genre he had been practising for two years. Here, the French ships are set against the light, positioned at right angles on a glassy sea that merges with the softness of the sky. As with certain views of the camp at Châlons-sur-Marne, Le Gray has succeeded in transforming the display of military might into a dreamlike vision.

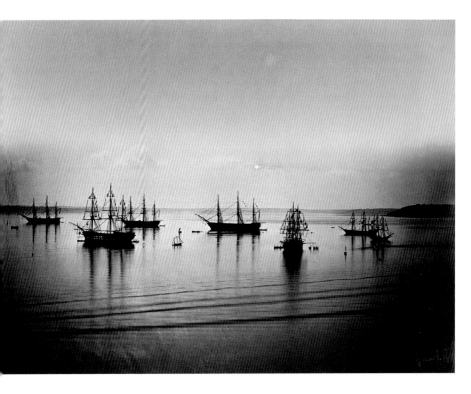

Quai de l'Hôtel-de-Ville and Pont d'Arcole, Paris, 1858–9. The picturesque fragments in the foreground are unusual for Le Gray. However, the dominant feature is the composition as a whole, with a flowing, luminous sequence formed by the embankment, the bridge and the buildings.

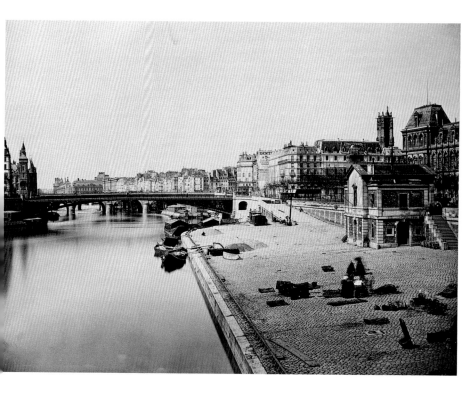

The Passerelle des Arts and the Quai de Conti, Paris, 1858–9. This image forms the right-hand side of a panorama, but the fact that it was circulated alone indicates that Le Gray also considered it to be a work of art in its own right. The boat belonging to the ladies' swimming school in the foreground effectively connects with the bridge and the embankment, forming a zigzag which leads the eye into the distance. Most views of Paris taken in Le Gray's time also feature either monuments or views of the Seine and its embankments. But Le Gray's works, more vibrant and luminous in quality than those of any other photographer, make a particularly strong impression on us today.

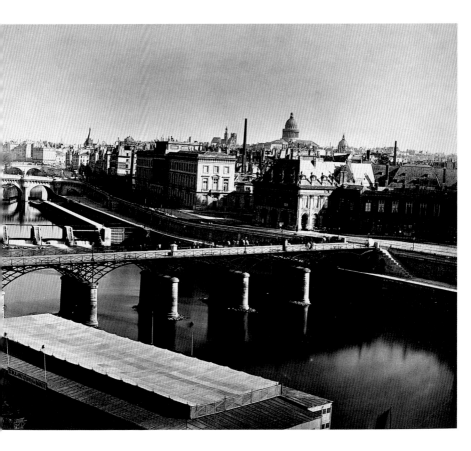

Portrait of Alexandre Dumas, Paris, 1859. Le Gray met Alexandre Dumas in 1859 when the writer was preparing for the epic journey to the East of which he had always dreamed. He then made several portraits of Dumas, at which the latter expressed his 'wonder'. At that time, Le Gray wanted to leave Paris, and Dumas needed an artist to record images of his cruise. This voyage was to be short-lived, as was the friendship between the two men. Here is the most natural of all the portraits of Dumas – caught during a moment of spontaneity, he has forgotten to play his own role.

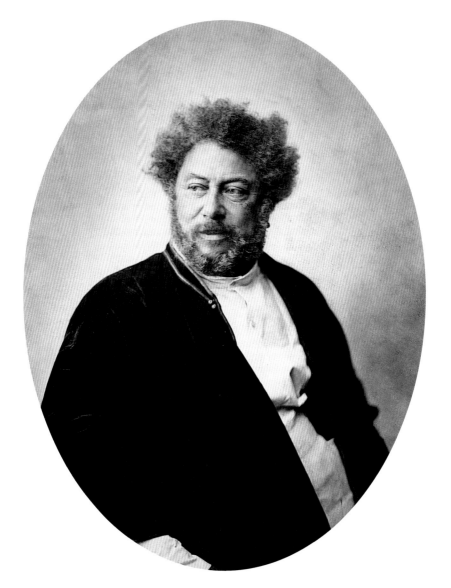

Portrait of Giuseppe Garibaldi, Palermo, Sicily, 1860. This portrait, which was reproduced as a print to be published in the journal *Le Monde Illustré*, has captured the unstinting energy of the 'Hero of Two Worlds', revolutionary leader and creator of Italian political unity, with a rare feeling of immediacy. According to Alexandre Dumas, it brought tears to the eyes of Italian patriots.

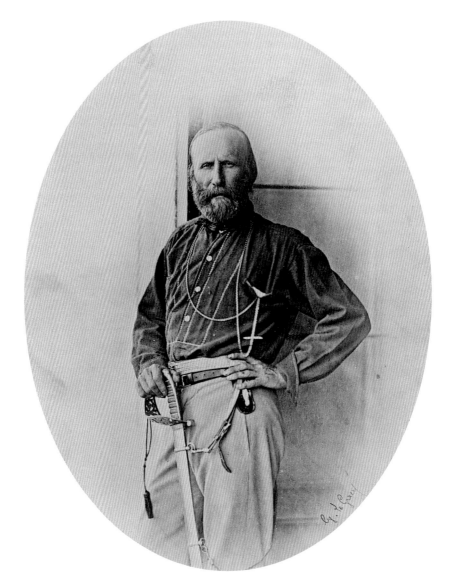

Via Toledo: General Türr's Barricade, Palermo, Sicily, 1860. This famous image of the calm amid the storm combines in one dramatic symbol the view of the deserted city towards the Porta Nuova, the ghostly flutterings of the awnings and tricolour flags, the enormous still life of a skilfully constructed barricade, and the powerful effects of light and shade. István Türr, a Hungarian patriot, joined Garibaldi in 1859 and took part in the conquest of the Two Sicilies.

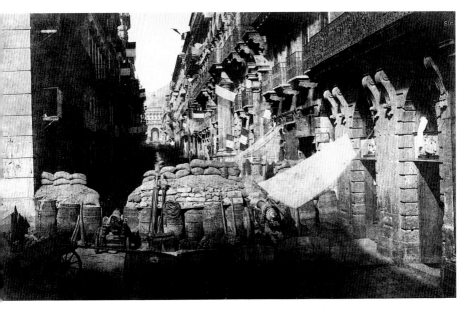

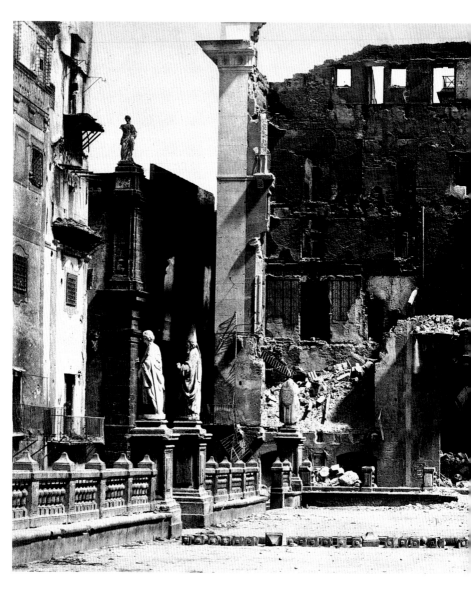

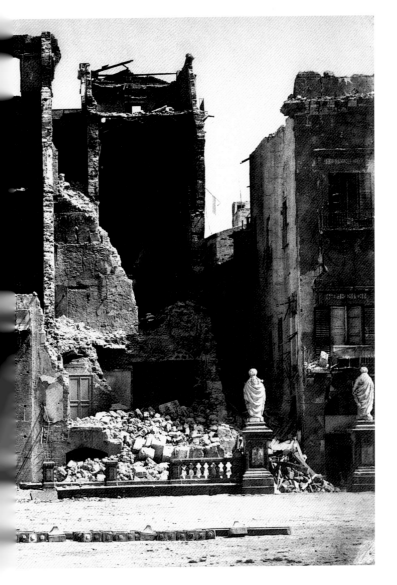

(previous page) Palazzo Carini, Palermo, Sicily, 1860. After General Garibaldi had taken the city of Palermo from the Bourbon kings of Naples and Sicily, it was severely shelled by the royal army. Garibaldi asked Le Gray to make a series of photographs of the city so that all Europe could know what the siege had been like. Seven such views were sent to Paris for printing and distribution. This one in particular is a fine geometrical composition. Its horizontal and vertical lines combine with a strong contrast of light and shade. It is animated by a number of statues, which stand out in white against the dark streets and silently turn their backs on the grand ruins of an aristocratic *palazzo*.

The Choubrah Promenade, Cairo, 1861–2. The immensely long promenade at Choubrah, shaded by sycamore trees, was an elegant and fashionable avenue, described by the poet Gérard de Nerval as 'unquestionably the most beautiful in the world'. The railings of the pasha's palace may be seen on the left; the opposite side of the building overlooked the Nile. The conventions of photography are stretched to the utmost by the presence of the dark, oval-shaped halo and the blurred group of strollers punctuating the perspective, accentuating the vivid impression created by the tree trunks, branches and light.

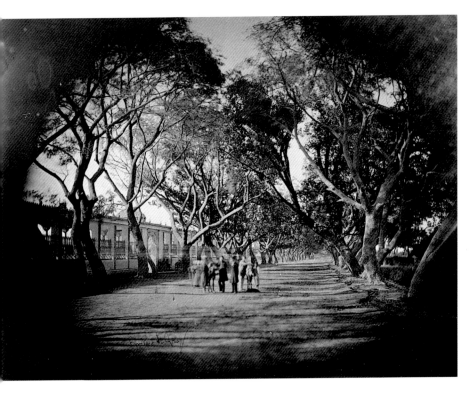

Labourers, Egypt, 1861–2. Le Gray's early work in Alexandria included images of typical Egyptians in the small *carte-de-visite* (visiting card) format. Although most of these were set up in the studio in the traditional manner, this scene, spontaneously captured in the sunshine, breaks free from the standard examples offered to tourists. The authentic, true-to-life quality emanating from the picture heralds the aesthetic principles of instant photography, and subsequently of photo-reportage.

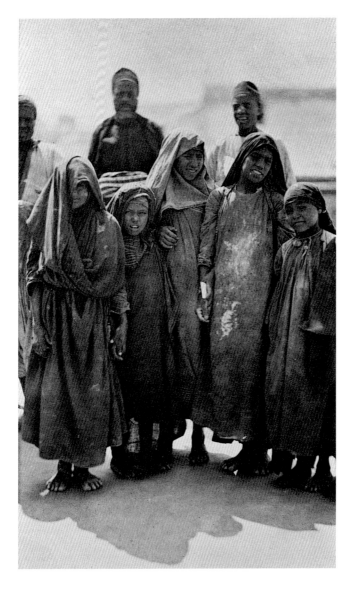

Young Boy in a Doorway, Egypt, 1861–7. This portrait of a young boy in a natural setting forms part of an as yet little-known series. Here Le Gray has successfully combined the theme of the portrait with that of picturesque representation, while integrating familiar elements into the decor that would appeal to Western eyes. This is the photographic version of the Oriental subjects popularized by such painters as Jean-Léon Gérôme, Le Gray's fellow student and friend. If we compare this work with the previous photograph, which is more artless and modern in appearance, or with the work on page 117, with its highly artificial composition, it is clear that Le Gray had great independence of vision, masterfully exploiting the potential offered by photography.

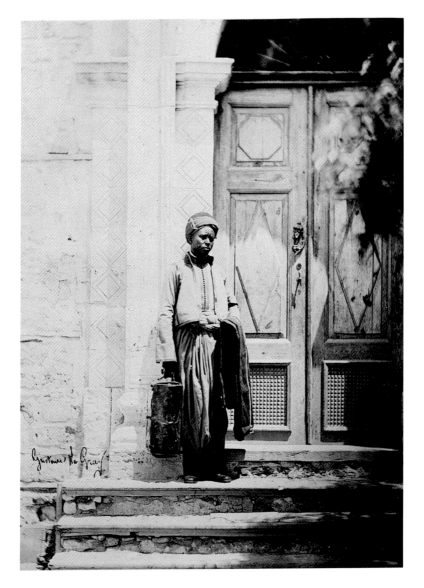

The Prince of Wales and His Entourage, Cairo, 1862. In 1862 the Prince of Wales travelled to the East, accompanied by his personal photographer, Francis Bedford. However, he asked Le Gray, who was still renowned in England, to take his photograph. This slightly eccentric image shows the prince and his companions posing on the steps of a Western-style residence together with their indigenous entourage, armed with what appear to be long local pipes. In Egypt Le Gray remained a favourite photographer of princes, as he had formerly been in France.

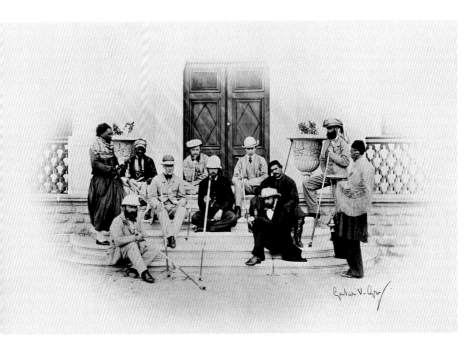

Camel Carrying Artillery, Cairo, 1866. In March 1866, Ismaïl Pasha asked Le Gray to photograph military arrangements for transporting pieces of artillery across the desert. These were to be used to quash the revolt of rebel Sudanese tribes. This series of photographs is a curiously exotic version of the images of the camp at Châlons-sur-Marne. With its lucid composition and majestic central subject, which stands out against the shadowless black-and-white background, this is the best of Le Gray's known works for this series.

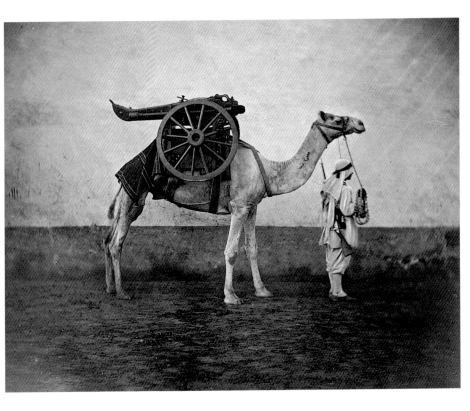

Party in Honour of Ismaïl Pasha on Board the Boats Belonging to the Princes, Egypt, 1867. In January 1867 Le Gray accompanied the pasha's sons on a cruise down the Nile. He was asked to teach them drawing and compile a photograph album of the journey. Here, abandoning architectural matters, he has photographed one of the events which took place on board, a party held in the pasha's honour. The steamboats, a visible sign of the Egyptian royal family's readiness to adopt Western innovations, are wreathed in smoke and decorated with paper lanterns and palms. This is an image of the modern Orient, where royal entertainment is little different from that of European sovereigns.

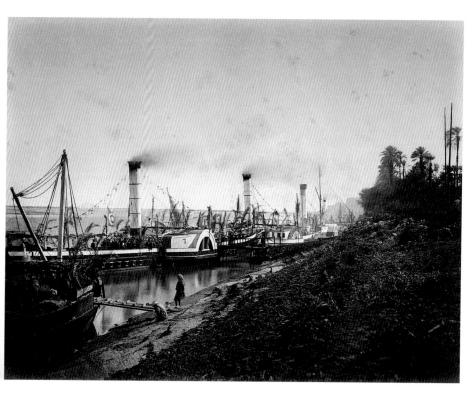

Temple of Edfu, Egypt, 1867. This is a general view of the Temple of Edfu, the courtyard of which inspired Le Gray to make a series of pictures as extensive as those he took of the tombs of the caliphs in Cairo. While the interior shots (page 125) give the impression of inhuman proportions and perfection, seen from the exterior the monument seems almost small, set in a limitless landscape between the dunes and sky. This shot would be banal and documentary in style, similar to thousands of other Egyptian architectural photographs taken at the time, if it did not act as a striking counterpoint to the interior shots. In passing from one to the other, one becomes acutely conscious of the distortion that photography imposes on our perceptions.

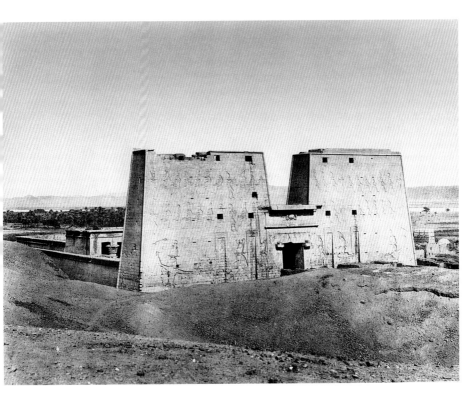

Temple of Edfu, Egypt, 1867. Le Gray brought back a wealth of monumental images from his journey down the Nile with Ismaïl Pasha's sons. The photographs may be compared to his finest Parisian works. Here, solid masses and empty spaces are linked in a continual succession, together with the vertical forms of the columns framed between thin horizontal bands of shadow. The group of figures forms the nucleus of a network of lines, placed close to both the intersection of the architectural planes and the focus of the receding lines. The white-clad figure in the centre of the group could well be the French Egyptologist Auguste Mariette Bey, who at that time was in charge of the major archaeological excavations carried out for the French government.

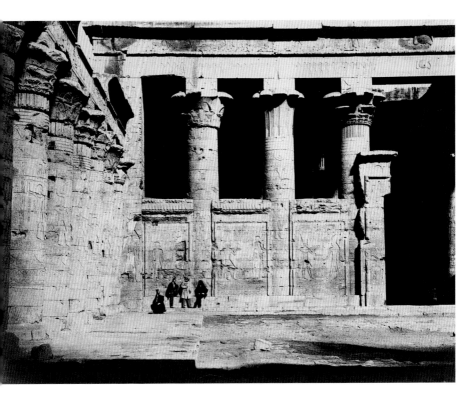

1820 Born 30 August at Villiers-le-Bel.

1839 Passes his baccalauréat. Announcement of the invention of the daguerreotype.

1840–1841 Le Gray is a clerk to a notary in Villiers-le-Bel.

1842 Becomes a pupil of Paul Delaroche.

1843–1844 Moves to Italy and marries Palmira Leonardi.

1847 Returns to Paris.

1848 Following on from the daguerreotype, Le Gray takes up photography on paper negatives. Two of his paintings appear at the Salon.

1849 Two out of three of Le Gray's children die, probably of cholera. Awarded bronze medal at the National Exhibition of Agricultural and Industrial Products. Moves house to the Barrière de Clichy. Pupils soon flock to his studio.

1850 Experiments with collodion glass negatives. Publication of his *Traité pratique de photographie sur papier et sur verre*. Le Gray photographs the Salon, as he also does in 1852 and 1853.

1851 Founding of the Société Héliographique. Perfecting of the dry waxed paper process. From July to October Le Gray and Mestral tour south-west France for the Mission Héliographique. Coup d'état by Louis-Napoléon Bonaparte on 2 December.

1853 Contemplates turning his workshop into a photographic printing house. Exhibits a painted portrait of his wife at the Salon.

1854 Founding of the Société Française de Photographie. Le Gray joins the administrative committee.

1855 Exhibits photographs at the Paris Exposition Universelle. Creation of the Gustave Le Gray & Co. Society, with the marquis de Briges as partner. Rents a studio at 35 boulevard des Capucines.

1856 Travels to Normandy and produces first seascapes. *Brig* shown in

London. Triumphant reception and many commissions. Trip to Sète, photographs the port and seascapes, among them *The Great Wave* and *The Broken Wave*. The sons of the marquis de Briges, now deceased, renew the limited partnership.

1858 Appears in numerous exhibitions in Britain during this and the following year. Perfects gold chloride toning for the production of prints on albumen paper. Photographs seascapes at Cherbourg and Brest, on the occasion of the English royal couple's visit.

1860 Winding-up of the Gustave Le Gray & Co. Society. Le Gray accompanies Alexandre Dumas on a cruise in the Mediterranean. They are received by Garibaldi in Palermo. Le Gray, Lockroy and Albanel are abandoned on Malta. *Le Monde Illustré* employs them to follow the troubles in Syria. Le Gray's leg is broken by a horse while *en route* for Damascus. Sentenced for debt to the de Briges brothers.

1861 Arrives in Alexandria.

1862 Steps taken by Madame Le Gray, abandoned with her two surviving sons, to locate her husband and to obtain a maintenance allowance.

1863 Appears on the list of French notables in Alexandria. Sends photographs to French newspapers.

1864 Takes up residence in Cairo. He begins his career as an art teacher in the military academies in Cairo and keeps this post until his death.

1865 Last request for assistance from Madame Le Gray, who is without resources in Marseilles. We subsequently lose trace of her.

1867 Travels along the Nile with the pasha's sons, Le Gray produces drawings and photographs. These works then appear at the Exposition Universelle in Paris, in the Egyptian section.

1883 Birth of Hélène, daughter of Le Gray and Anaïs Candounia.

1884 29 July, death of Gustave le Gray in Cairo.

Photography is the visual medium of the modern world. As a means of recording, and as an art form in its own right, it pervades our lives and shapes our perceptions.

55 is a new series of beautifully produced, pocket-sized books that acknowledge and celebrate all styles and all aspects of photography.

Just as Penguin books found a new market for fiction in the 1930s, so, at the start of a new century, Phaidon **55**s, accessible to everyone, will reach a new, visually aware contemporary audience. Each volume of 128 pages focuses on the life's work of an individual master and contains an informative introduction and 55 key works accompanied by extended captions.

As part of an ongoing program, each **55** offers a story of modern life.

Gustave Le Gray (1820–84) was among the first to claim that photographs should be thought of as artworks in themselves. Originally a painter, Le Gray became the first great teacher in the history of the photographic medium. His interest in experimentation and high technical standards jeopardized his commercial success, however, and he ended his career in Cairo as a teacher of drawing.

Sylvie Aubenas is chief curator of the nineteenth-century photographic collections at the Bibliothèque Nationale, Paris. She has curated several exhibitions on the work of such photographers as Nadar, Charles Aubry and Le Gray.

Phaidon Press Limited
Regent's Wharf
All Saints Street
London N1 9PA

Phaidon Press Inc.
180 Varick Street
New York NY 10014

www.phaidon.com

First published 2003
©2003 Phaidon Press Limited
ISBN 0 7148 4234 6

Designed by Julia Hasting
Printed in Hong Kong

A CIP record of this book is available from the British Library. All rights reserved. No part of this publication may be reproduced, stored in a retrieval system or transmitted in any form or by any means, electronic, mechanical, photocopying, recording or otherwise, without the prior permission of Phaidon Press Limited.

Thanks to: Metropolitan Museum of Art, NY; Gilman Paper Company Collection; © CMN, Paris; ©Michel Urtado; The J. Paul Getty Museum, LA; Bibliothèque Nationale de France; National Gallery of Canada; Musée des Beaux Arts, Cleveland; Musée d'Orsay – RMN; Musées d'Art et d'Histoire de Troyes; Collection Marc Lecoeur; Collection Michael Sachs; Musée de Tel Aviv; Hans P. Kraus Gallery, NY; Collection Suzanne Winsberg; Manufacture de Sèvres.